ARIZONA'S BACKCOUNTRY

PHOTOGRAPHS BY JOEL HAZELTON

Photographs: JOEL HAZELTON
Editor: KELLY VAUGHN
Designer: KEITH WHITNEY
Copy Editor: NOAH AUSTIN
Photo Editor: JEFF KIDA

ISBN: 978-0-9989812-2-2
First printing, 2019. Printed in Canada.

ARIZONA
HIGHWAYS

Published by the Book Division of *Arizona Highways* magazine, a monthly publication of
the Arizona Department of Transportation, 2039 W. Lewis Avenue, Phoenix, Arizona, 85009.
Telephone: 602-712-2200
Website: www.arizonahighways.com

Publisher: Kelly Mero
Director of Sales and Marketing: Karen Farugia
Editor: Robert Stieve
Senior Editor/Books: Kelly Vaughn
Associate Editor: Noah Austin
Creative Director: Barbara Glynn Denney
Art Director: Keith Whitney
Photography Editor: Jeff Kida
Editorial Administrator: Nikki Kimbel
Production Director: Michael Bianchi
Production Coordinator: Annette Phares

COVER: Photographer
Joel Hazelton made this
photograph of sunrise over
Lithodendron Wash at Petrified
Forest National Park, near
Holbrook, during a summer
backpacking trip with his dog,
Cholla. "We walked to where we
found an alcove and napped
for three hours until the heat
passed, then scouted this
shot," Hazelton says. "The next
morning, we had that little bit
of sun that peeked out."

BACK COVER: Wispy clouds are
reflected in the still waters of
Boneyard Creek in the White
Mountains of Eastern Arizona.

ARTIST'S STATEMENT

When planning my next adventure, I rarely start by asking myself, "Where can I get the best photo?" While there are weather conditions, sun angles and seasons that I consider when plotting my routes, these are just technicalities that come with the job. Rather, the question I ask myself to inspire my artistic process is: "Where in Arizona do I want to explore next?"

My passion for photography and the outdoors starts with maps. I can get lost for hours in a topographical map of Arizona — usually by following the path of a drainage, searching for a compression of contour lines that indicates where a waterfall exists, or a spot where the canyon walls squeeze into a dramatic set of narrows. I love the challenge of reading the landscape on paper and finding the most logical route from the trailhead to the destination, and then the satisfaction of successfully executing a planned itinerary.

In the field, I strive to reach those vantage points that are on the seasoned Arizona hiker's bucket list but aren't considered by many photographers due to inaccessibility. I used to avoid tough destinations because I didn't want to risk wasting time and effort and not getting a photograph. However, as I matured in my craft, I learned that complicated logistics, burned calories and battle wounds only added to the intimacy I felt with a place, and therefore inspired more thoughtful and thought-provoking work. Some of my best images are from destinations that may have been uninspiring had I not worked so hard to reach them.

Once I'm home, I'm usually scratching bug bites and nursing poison ivy rashes. But I also return to my maps to rescan my route, assessing what I thought would be there and recalling what *was* there. Eventually, I get lost again. Usually, it's another drainage, or a nearby peak, or maybe a completely different area where I feel I haven't spent enough time. Always, though, it's in Arizona.

— *Joel Hazelton*
Phoenix, Arizona, 2018

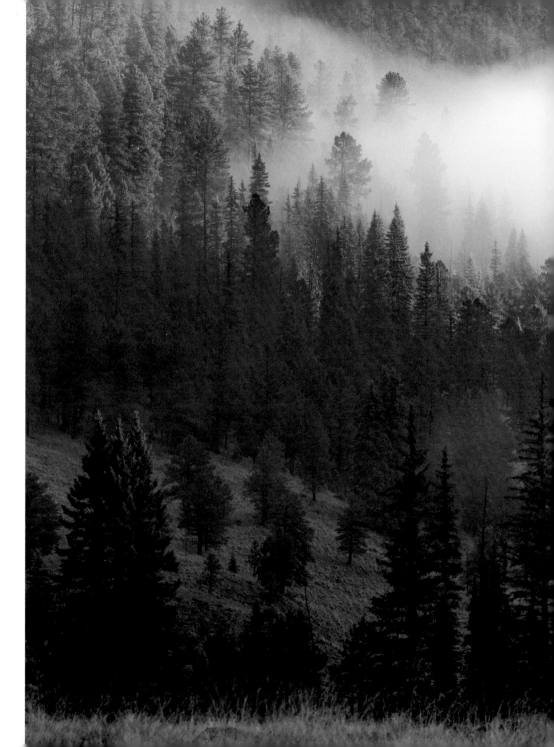

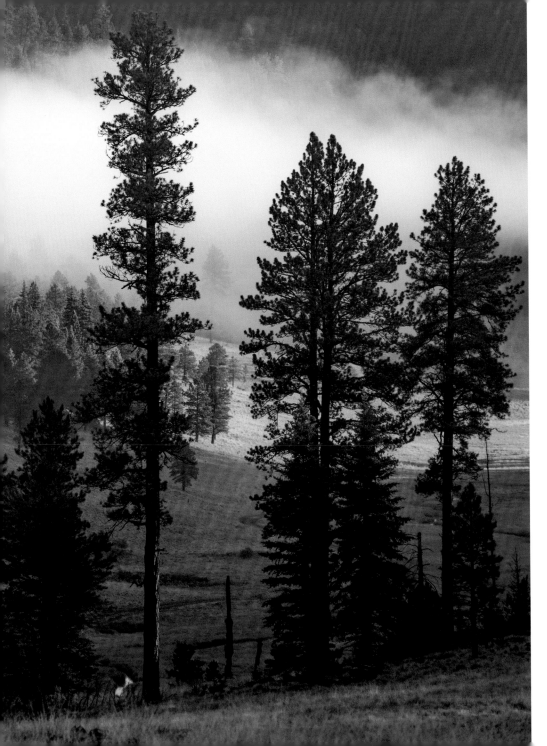

Hazelton almost didn't make the trip to capture this photograph of Boneyard Creek, in the White Mountains, because of weather. "My girlfriend, Kristen, and I had been stuck in a tent too many afternoons in a row because of rain," he says. "I proposed that we go home, but she didn't agree as enthusiastically as I thought she would. At sunrise, there was fog everywhere, and the light was incredible."

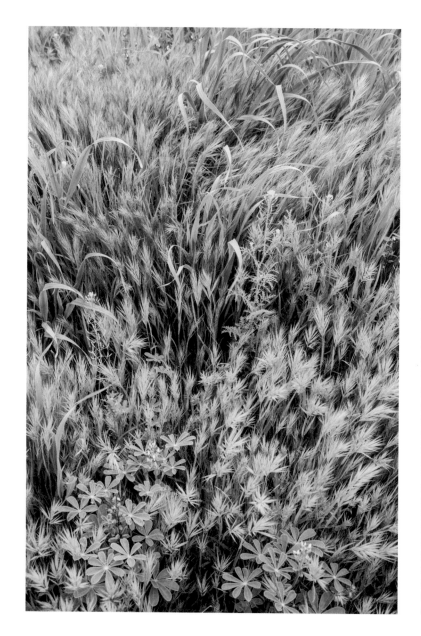

LEFT: "I found this field of grasses right across from Sunset Point on the first day of shooting for the Interstate 17 portfolio that ran in the March 2018 issue of *Arizona Highways*," Hazelton says.

RIGHT: A gnarled manzanita anchors this scene — a stormy sunset over Coal Mine Canyon on the Navajo Nation. "My friend Todd and I had done a backpacking trip along the Little Colorado River on the Navajo Nation," Hazelton says. "On the way back, we had an extra evening and decided to stop by Coal Mine. The sunset alone was worth it."

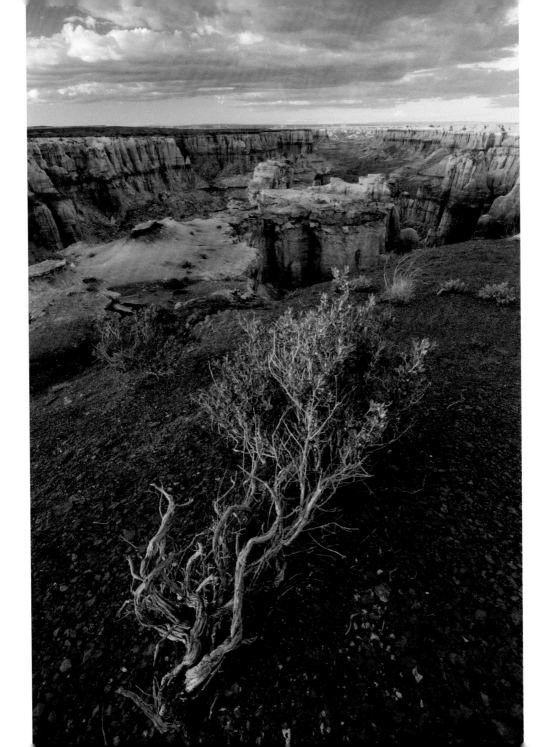

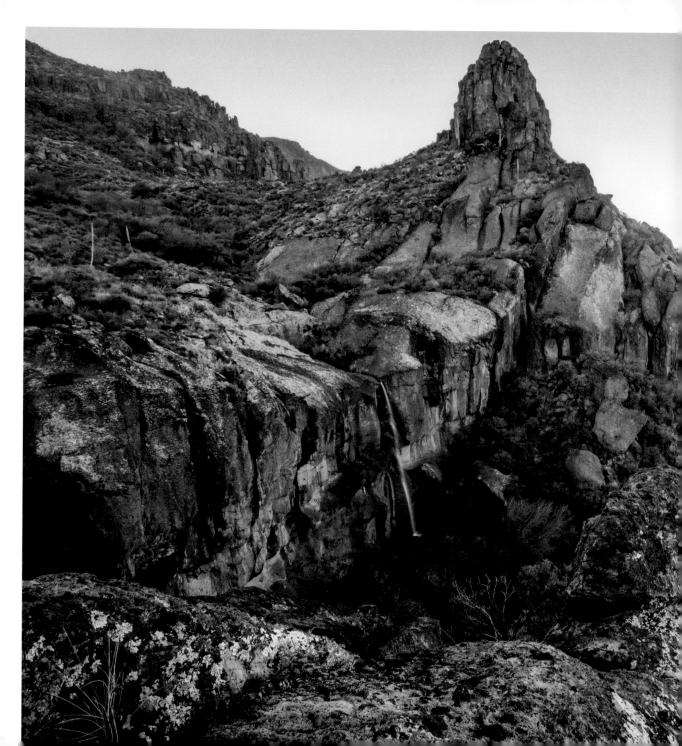

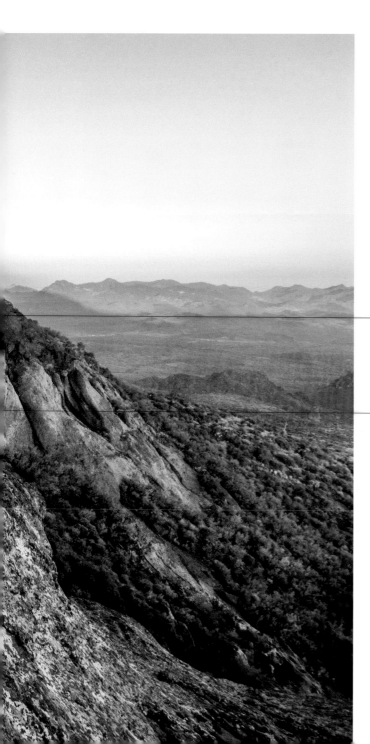

"I had been to Massacre Falls, in the Superstition Wilderness [east of Phoenix], several times back when I shot film, and I was waiting for the right time to go back," Hazelton says. "The falls will run like this the day after a big storm. I knew ahead of time that I wanted to approach from this angle, so I climbed up in the dark."

9

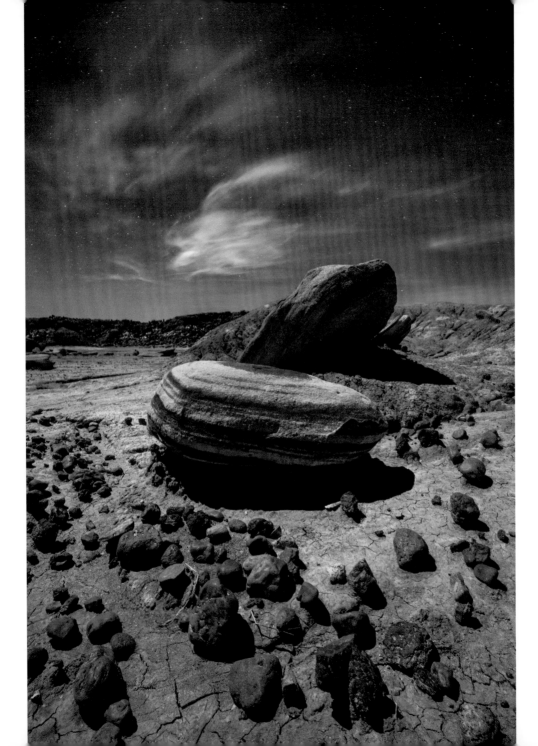

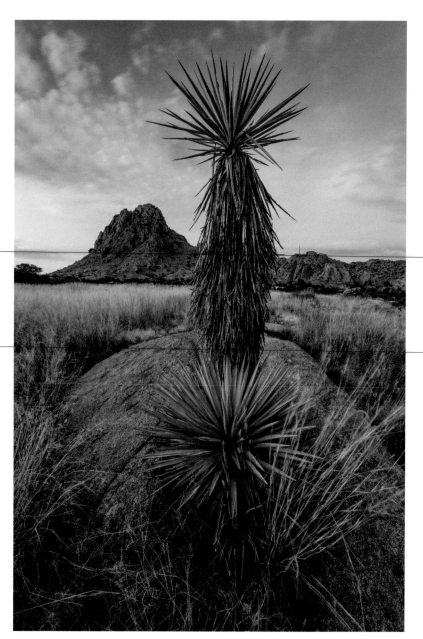

OPPOSITE PAGE: Hazelton captured this image, from the Devil's Playground area of Petrified Forest National Park, at 2 a.m. "This was my second backpacking trip there, and this bizarre area had been on my bucket list for a long time," he says. "It felt like a moonscape to me."

LEFT: Hazelton photographed this yucca from the Slavin Gulch Trail in the Dragoon Mountains of Southeastern Arizona.

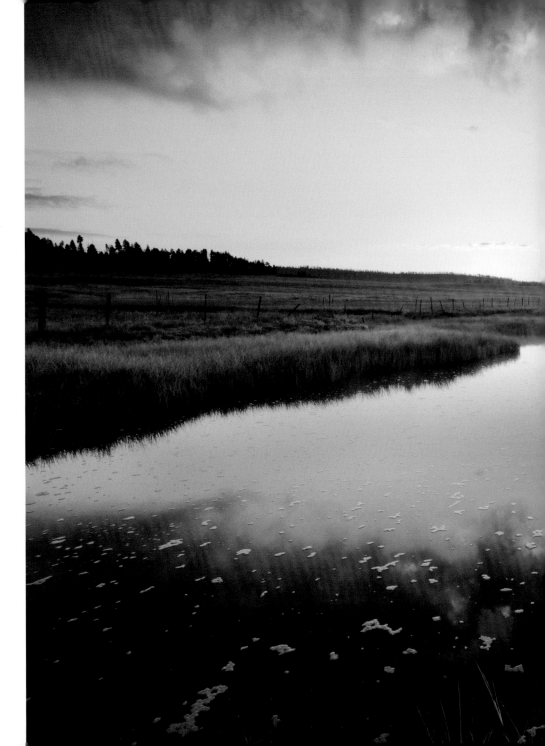

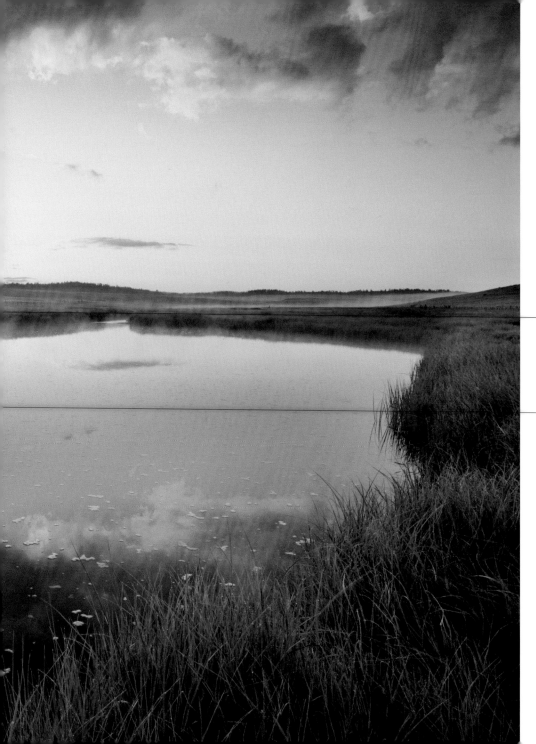

The East Fork of the Black River has long been one of Hazelton's go-to spots for photography. "You can just drive right up to the river in a passenger car at Crosby Crossing," he says. "The evening before I made this image was full of lightning, then rainbows. I ran down to the river to shoot, but my memory card was full, so I drove to Show Low to get a new one. I drove back and saw all the lightning I was missing."

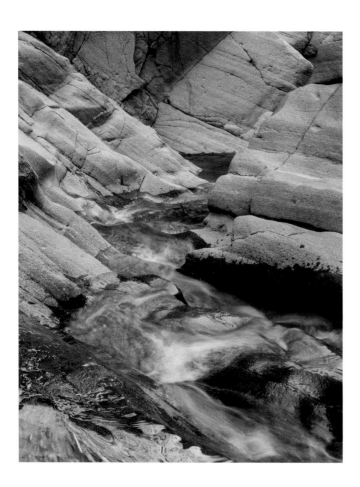

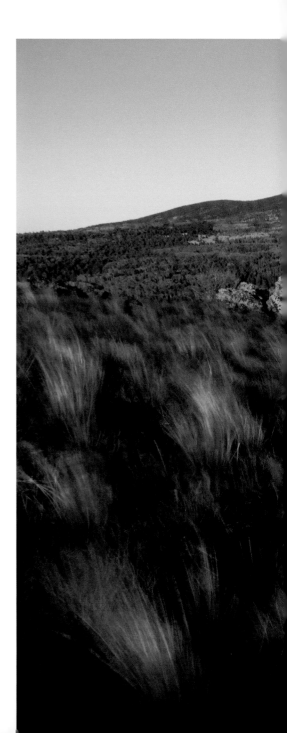

ABOVE: Water flows through Hells Canyon in the Hells Canyon Wilderness, northwest of Phoenix.

RIGHT: Evening light illuminates blowing grasses on the summit of Fern Mountain at Hart Prairie, near Flagstaff. Humphreys and Agassiz peaks are in the background.

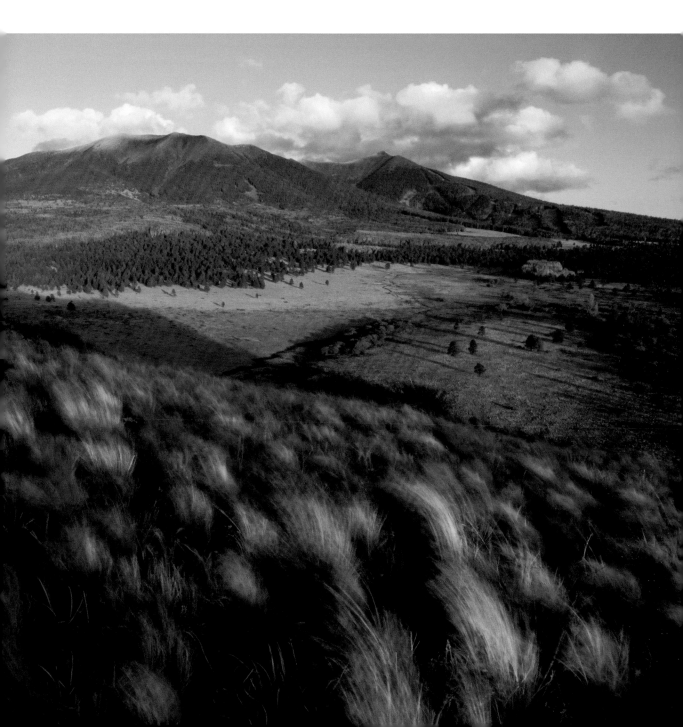

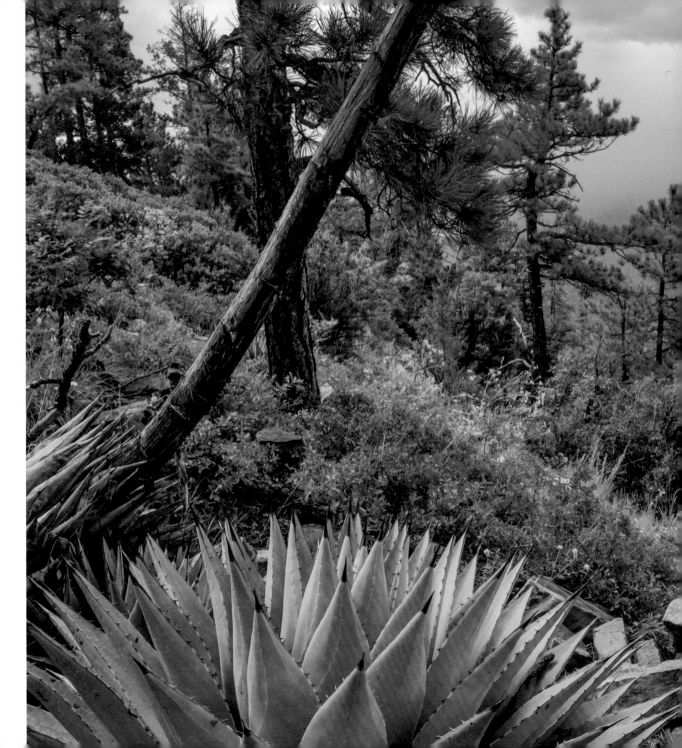

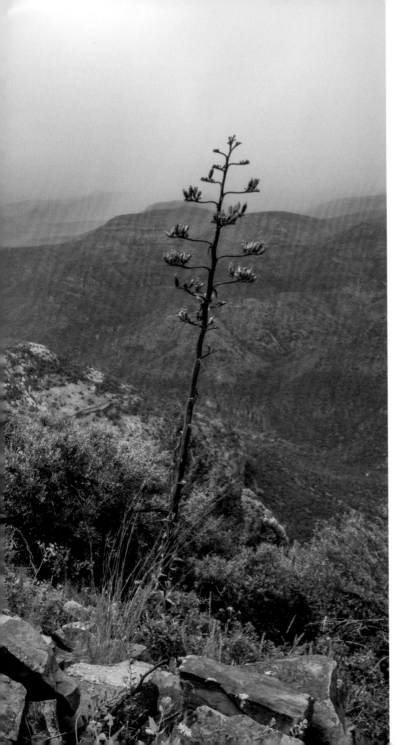

"Less than 30 seconds after I captured this photo in the Sierra Ancha Wilderness, there was a deafening clap of thunder," Hazelton says. "My girlfriend, our dog and I immediately scurried down to our tent, which was about 50 feet below the edge of the mountain. By the time we closed the tent, it was pouring rain, and we spent the next two hours peacefully napping to the sounds of the storm."

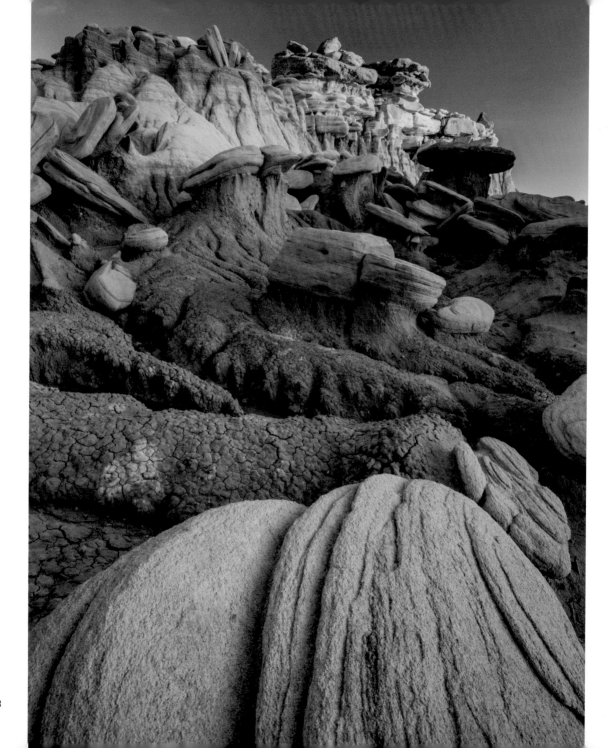

LEFT: Hazelton made this photograph in Petrified Forest National Park during a camping trip with friends. "This was one of those times when I had enough time to truly go through an entire area, find compositions and look at things and prepare," he says. "I found this area a few hours before I made the photograph and knew what the light was going to do. It was cool to go back when the light changed. The shot worked out really well."

RIGHT: West Clear Creek, a popular hiking and backpacking destination in the Coconino National Forest, is where Hazelton made this photograph of the Hanging Gardens in July 2018. "As my friends and I were hiking out, I hung back," he says. "West Clear Creek had been on my bucket list until it got so popular. We had hiked another area called the Red Box and had to pass by here on our way out."

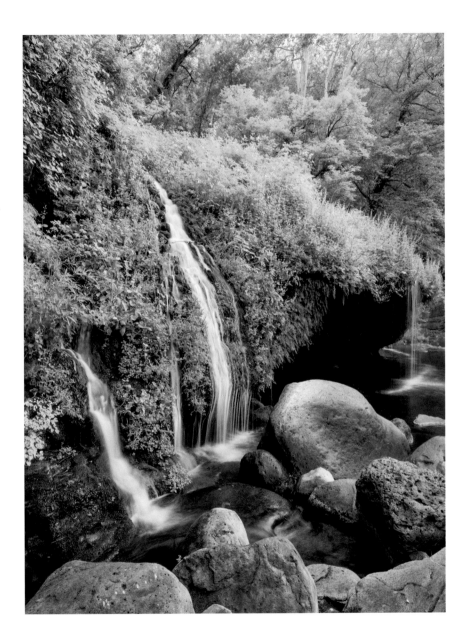

BELOW: A blooming hedgehog cactus overlooks the Hassayampa River Canyon Wilderness, northeast of Wickenburg. "My dog was the happiest I've ever seen any animal, ever," Hazelton says. "She was bounding across the river. That evening, I was going to leave, but I decided to shoot along the road when I saw these blooms."

RIGHT: Sunrise paints the sky pink behind SP Crater, near Flagstaff. "I don't know why I went to the crater," Hazelton says. "I was going to climb it, because I envisioned a shot of the Milky Way from the rim, but I didn't end up doing it. I shot these photos from the road instead. Sunrise was beautiful."

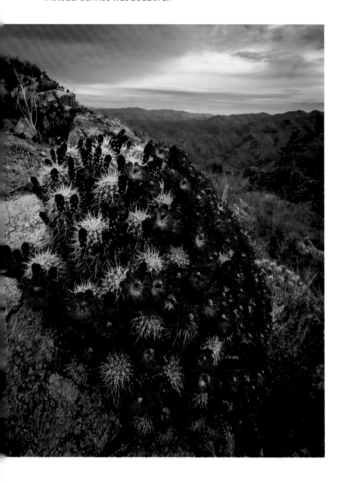

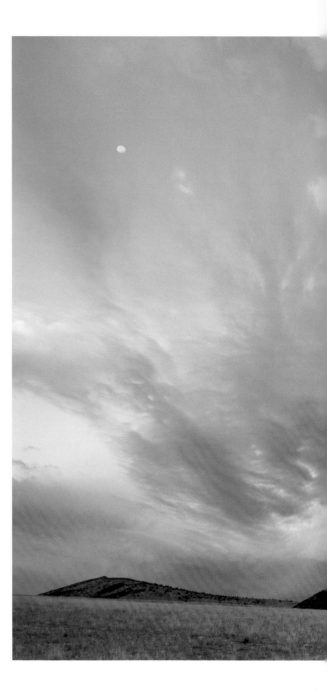

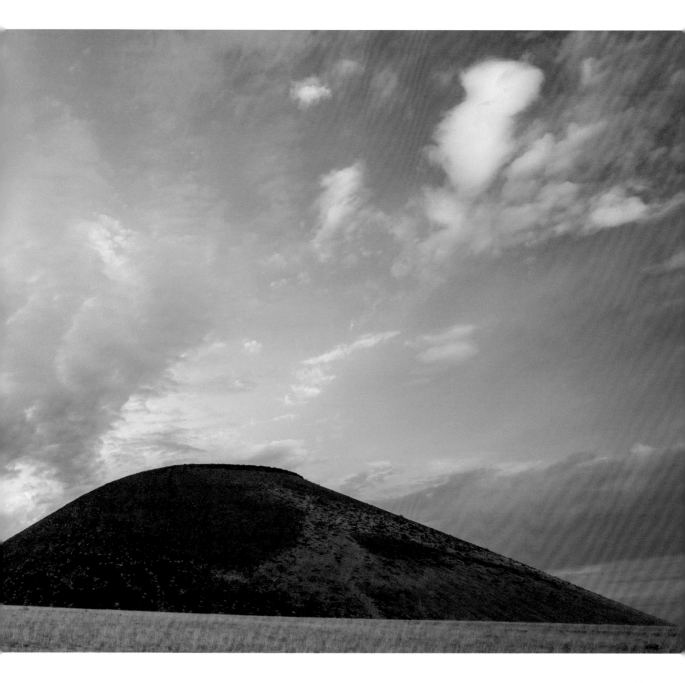

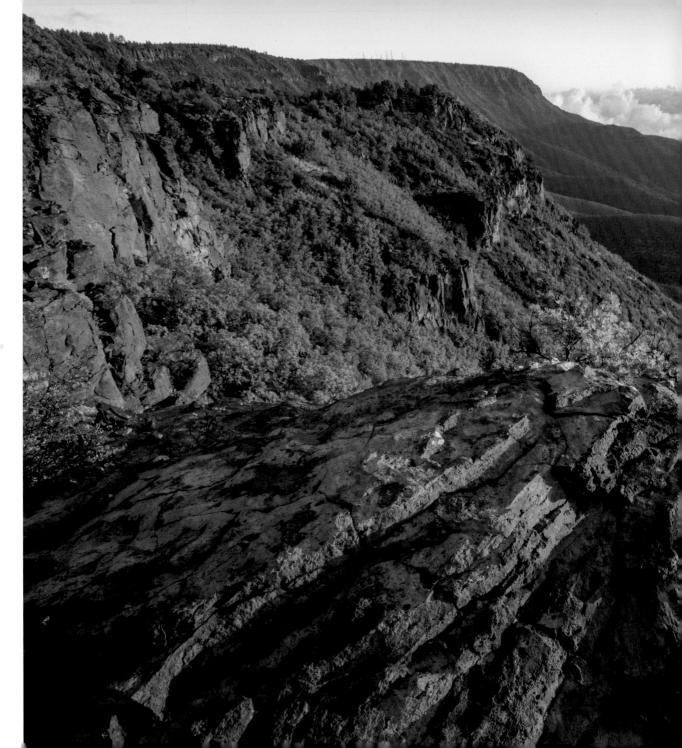

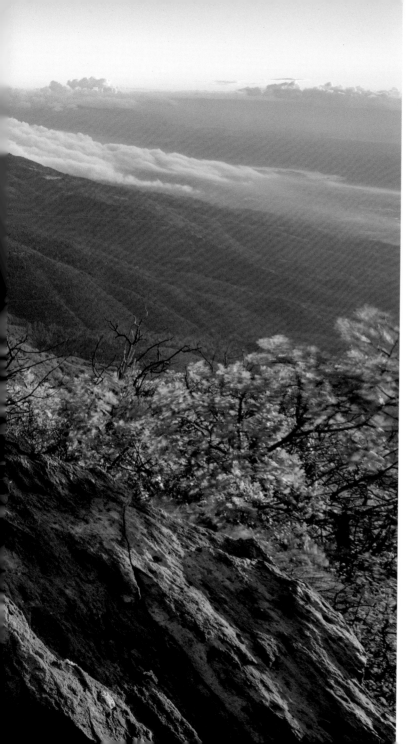

Hazelton made this photograph on Mingus Mountain in June 2018, after the season's first monsoon storm. "It drizzled all evening the night before I shot this," he remembers. "Views off the mountain were completely blocked off, but the next morning, there weren't any dramatic clouds. Instead, we had these nice, light clouds in the distance."

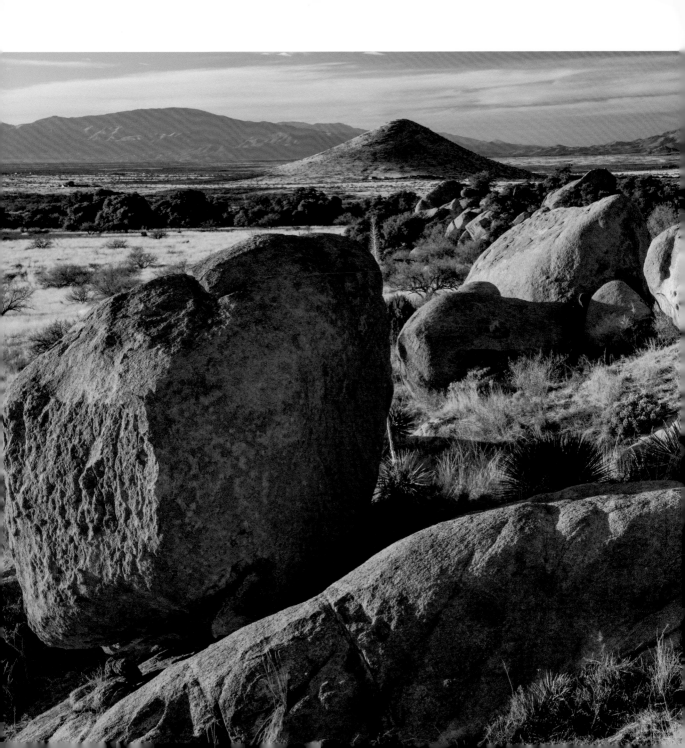

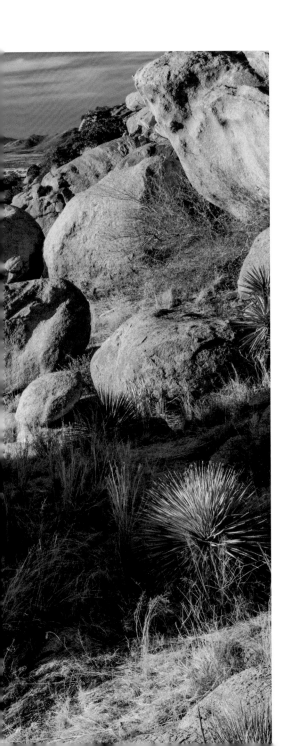

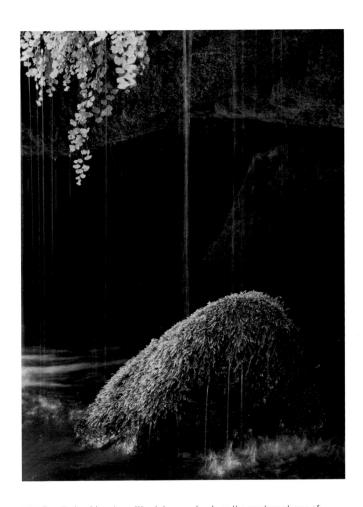

LEFT: Granite boulders transition into grasslands on the western slopes of the Dragoon Mountains of Southeastern Arizona. The Rincon Mountains fill the background.

ABOVE: Hazelton's goal for this image of the Hanging Gardens in West Clear Creek was to find something different. "This rock was really cool," he says, "so I shifted the composition to balance the water, the hanging plants and the rock."

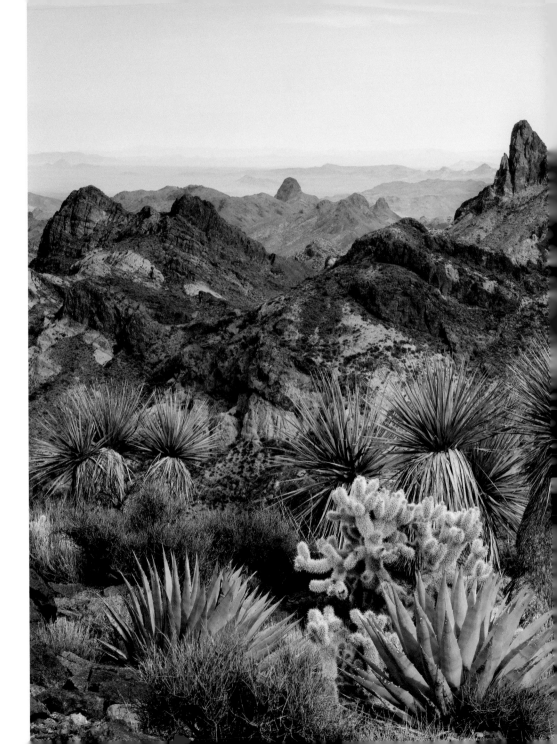

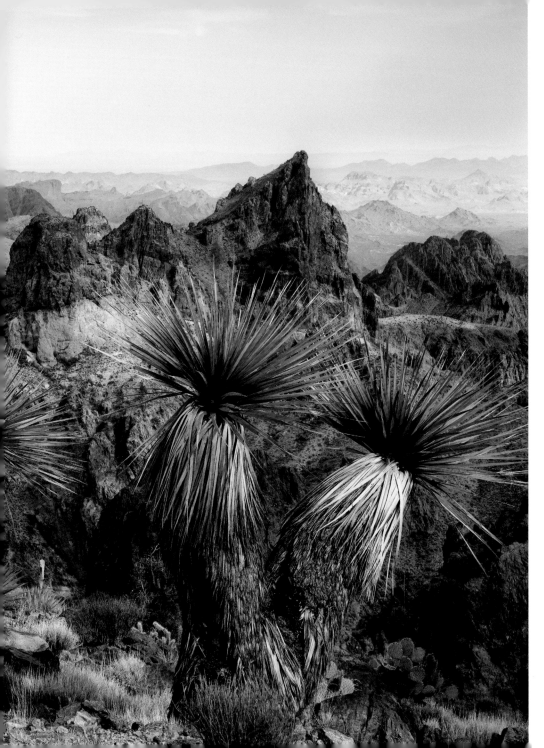

This type of capture is atypical for Hazelton. When he visited the Kofa Mountains one April, it was unseasonably cool. "It breaks the rules of light, really, to shoot at 1 or 2 p.m.," he says. "But something lined up here. I think the clouds were half blocking the sun, and I really lucked out with this strange, three-dimensional shot."

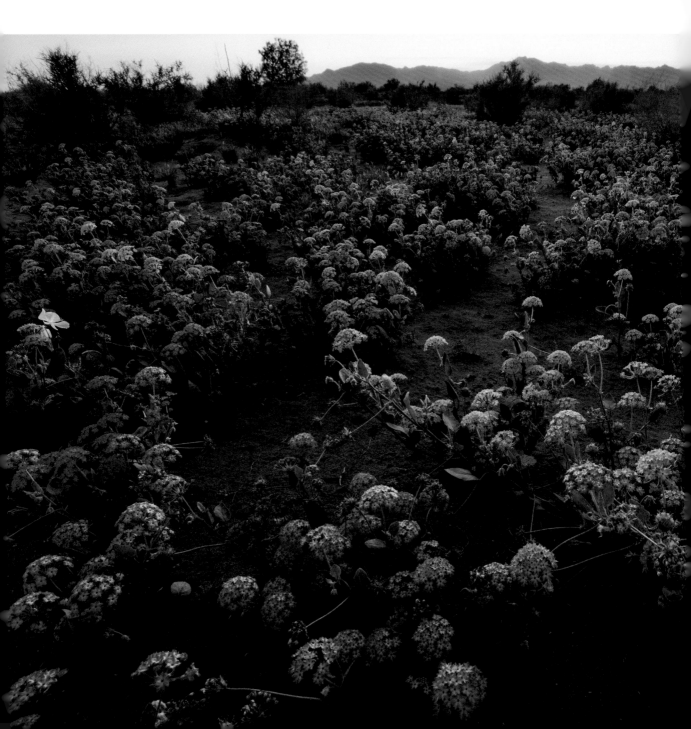

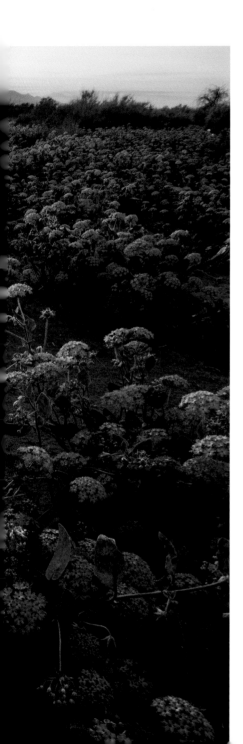

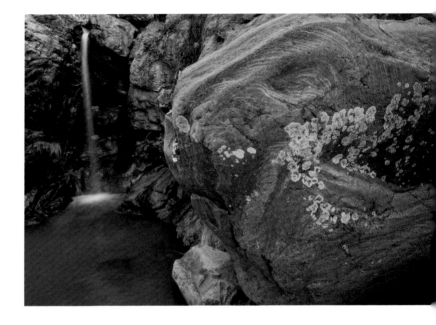

LEFT: Sand verbenas blanket the dry bed of the Gila River near the town of Maricopa.

ABOVE: "I had planned to go deeper into the Mazatzal Mountains, but I'd taken a half-day from work and gotten a late start because I had a sinus infection," Hazelton says. "I ended up setting camp in the dark, but I got up the next morning and found these beautiful falls along Rock Creek. I love shooting in the Mazatzals because of the color of the rocks."

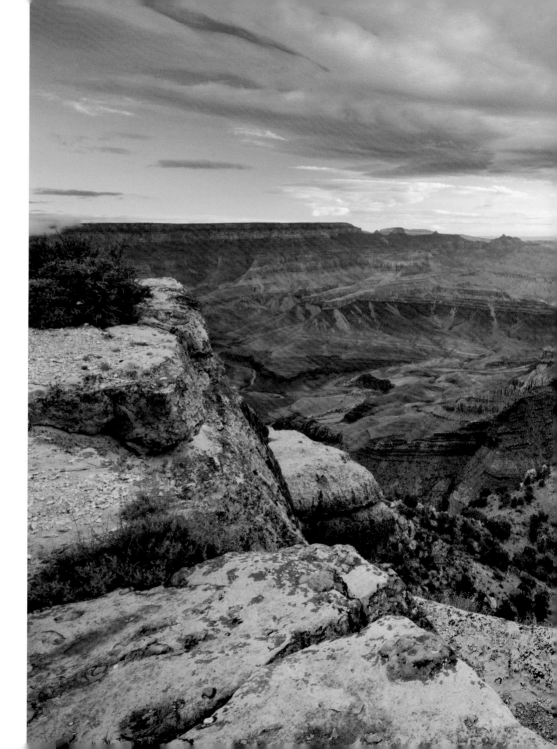

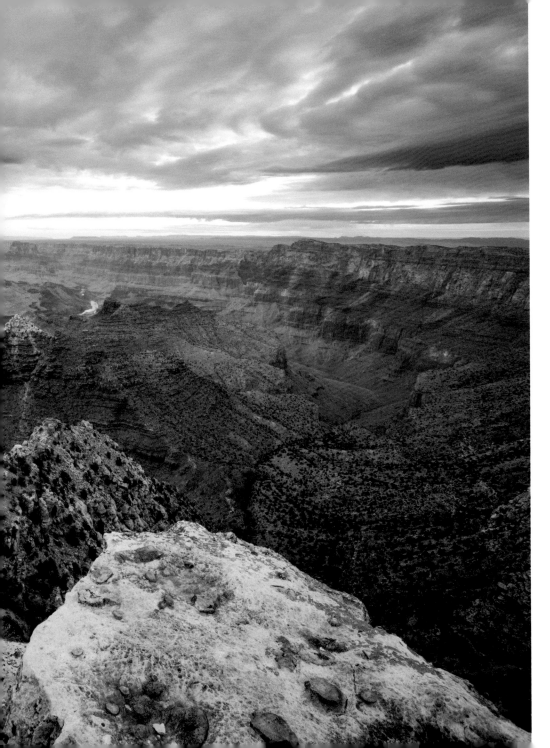

Hazelton made this photograph at the Grand Canyon's Lipan Point during a friend's wedding. "I didn't go to the actual wedding, because I was out shooting," he remembers. "But I did go to the reception."

BELOW: Blooming ocotillos and brittlebushes frame a view of the Agua Fria River south of Black Canyon City.

RIGHT: Jagged peaks in the Superstition Wilderness, east of Phoenix, are reflected in seasonal Boulder Creek. "As much as I dread having to frame a landscape shot with a clear sky, it forces creativity," Hazelton says. "That's where those water plants came in for this shot. I thought, *I have to make this other stuff work with that blue sky.*"

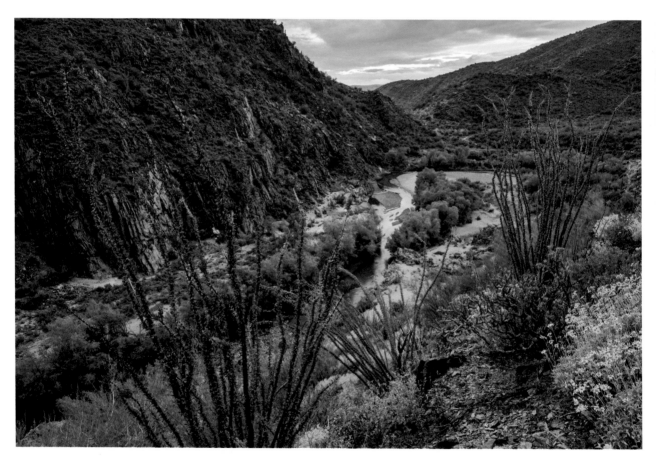

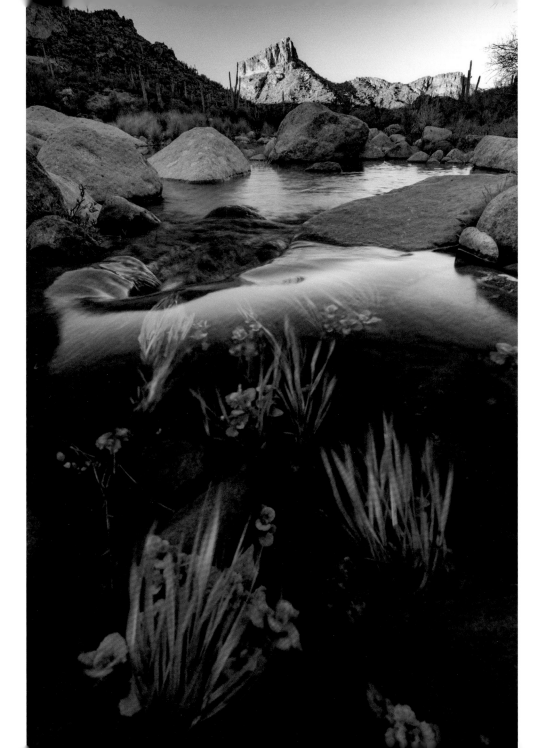

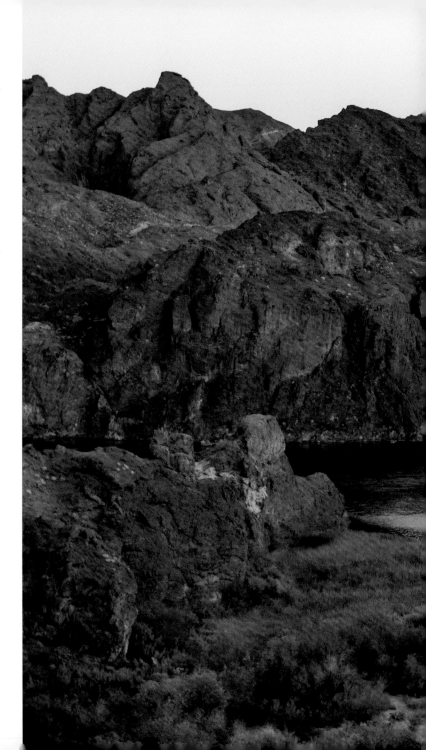

Hazelton's shot of Topock Gorge, along the Colorado River, was the result of the only hike he's ever done in the Mojave Desert. "I did this trip with another photographer, from California," Hazelton says. "I was actually on the California side, shooting into Arizona, when I made this. I climbed up a ridge and came face-to-face with a very angry burro. It was upset to the point that we thought it might attack us, but when we climbed down after dark, it was gone."

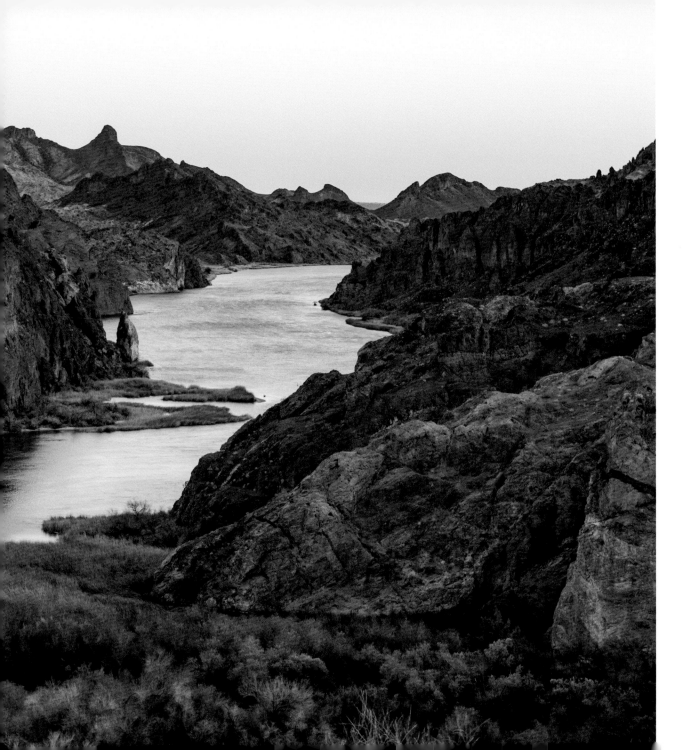

BELOW: A monsoon storm darkens the sky over the East Verde River.

RIGHT: Late-afternoon light paints rock formations and cactuses along the Apache Trail between Tortilla Flat and Apache Lake.

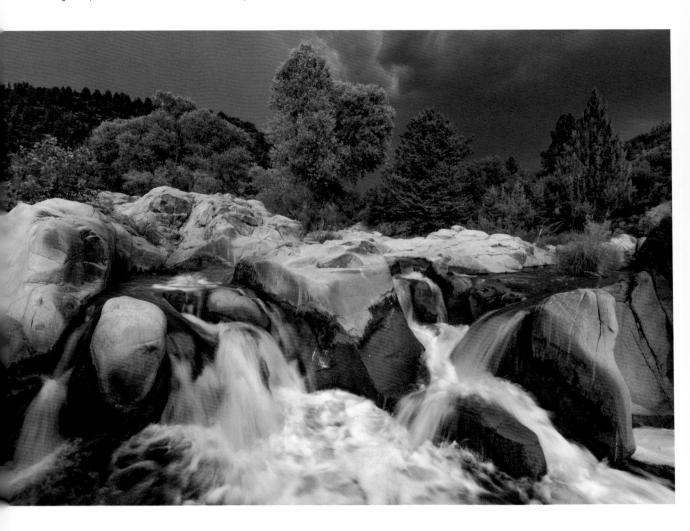

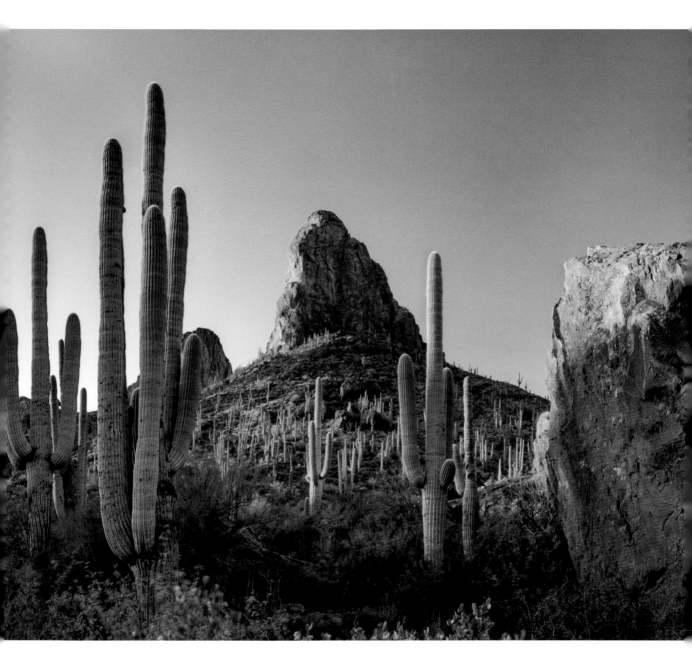

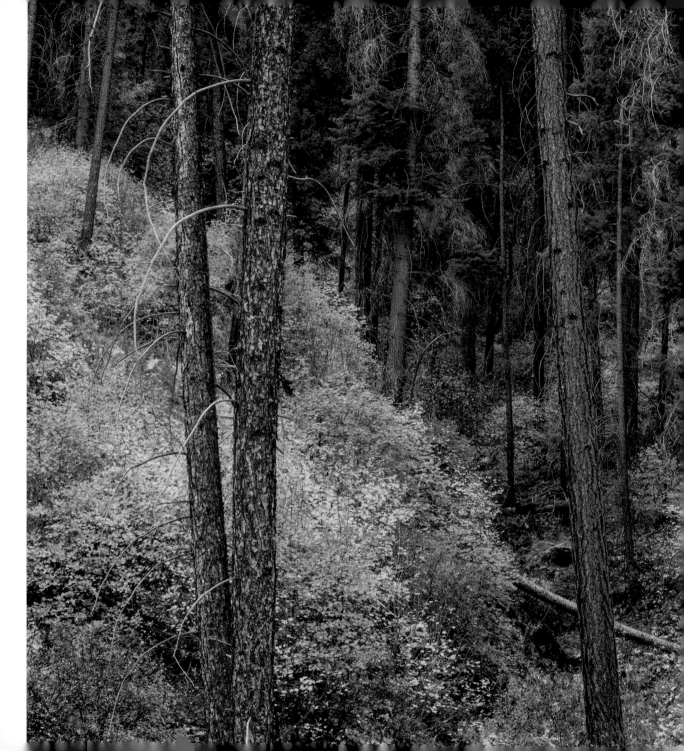

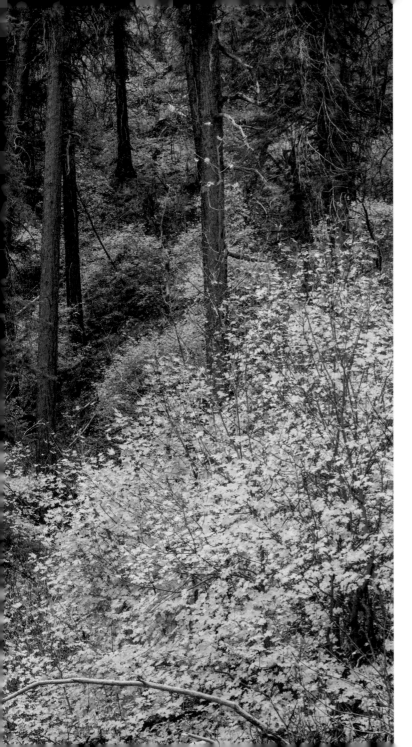

Autumn-hued maples flank a canyon along the Sterling Pass Trail in Sedona. "This was a tough area to shoot in because of a recent fire," Hazelton says. "There was plenty of fall color, but the burned backdrop made this shot challenging to compose."

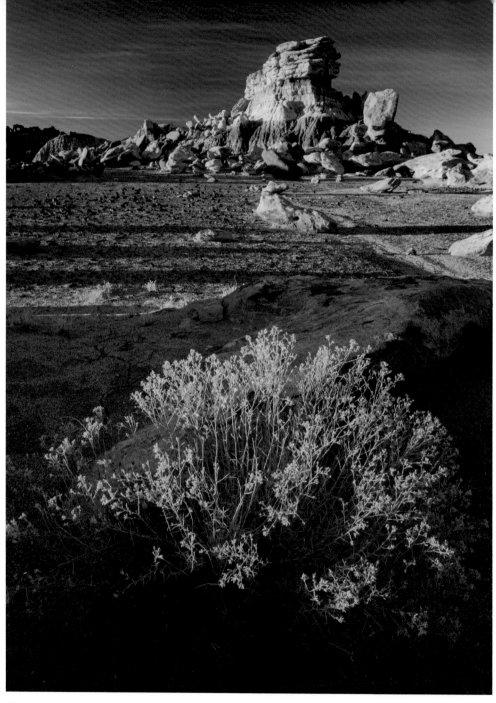

In this final shot from Petrified Forest National Park, Hazelton "liked how isolated that foreground plant was," he says. "And the sidelight really worked. It split the foreground and background to create a nice balance."